REMBRANDT
IN SOUTHERN CALIFORNIA

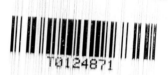

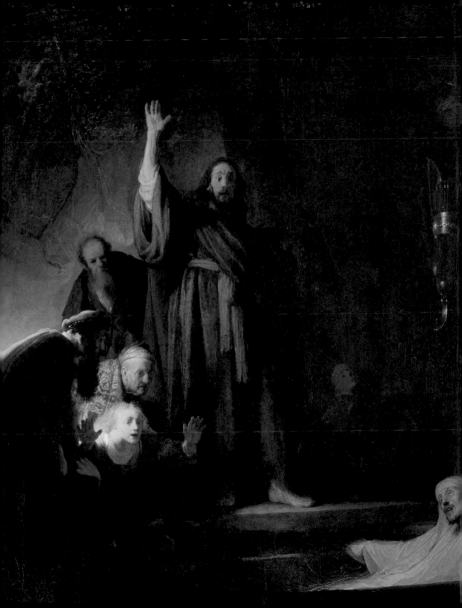

REMBRANDT
IN SOUTHERN CALIFORNIA

ANNE T. WOOLLETT

THE J. PAUL GETTY MUSEUM | LOS ANGELES

© 2009 J. Paul Getty Trust

Published by the J. Paul Getty Museum

Getty Publications
1200 Getty Center Drive, Suite 500
Los Angeles, California 90049-1682
www.getty.edu/publications

Gregory M. Britton, *Publisher*
Mark Greenberg, *Editor in Chief*

Benedicte Gilman, *Editor*
Catherine Lorenz, *Designer*
Stacy Miyagawa, *Production Coordinator*

Typeset by Catherine Lorenz in Deepdene
Printed in China through Oceanic Graphic Printing, Inc.

Unless otherwise noted, the illustrations have been provided by their owners and are reproduced by their permission.
Page ii: see no. 7; page vi: see no. 14; pages 6–7: see no. 4; page 36: see no. 5; page 46: see no. 11; page 50: see no. 2.

Library of Congress Cataloging-in-Publication Data

Woollett, Anne T.
 Rembrandt in southern California / Anne Woollett.
 p. cm.
 ISBN 978-0-89236-993-5 (pbk.)
 1. Rembrandt Harmenszoon van Rijn, 1606–1669—Themes, motives. 2. Art museums—California, Southern. I.
Rembrandt Harmenszoon van Rijn, 1606–1669. II. Title.
 ND653.R4W595 2009
 759.9492—dc22
 2009012231

CONTENTS

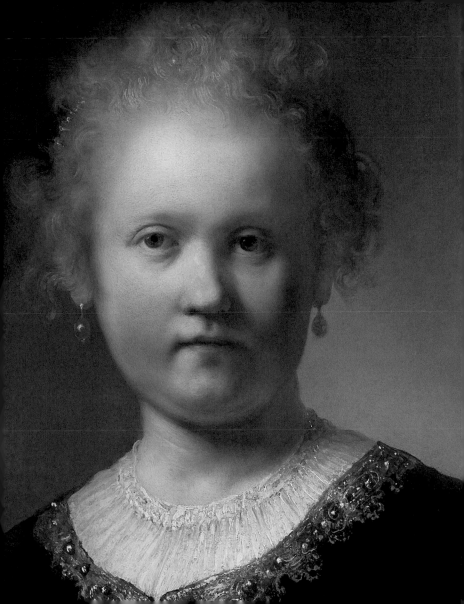

REMBRANDT
IN SOUTHERN CALIFORNIA

———

THE REMARKABLE ART OF Rembrandt Harmensz. van Rijn (1606–
1669) is magnificently represented in Southern California public collections
by an impressive group of fourteen paintings. From dramatic, small-scale his-
tory scenes of the early 1630s to powerfully expressive late figure subjects,
these works convey the dazzling range of Rembrandt's painting technique
and his individual approach to an array of subjects across his long career.
Together, they constitute the most substantial display of Rembrandt's artistic
achievement in the Western United States, surpassed only by the venerable
collections in New York and Washington, D.C. This book and the related
virtual exhibition (www.rembrandtinsocal.org) provide a guide to the paint-
ings by Rembrandt in the Hammer Museum, Los Angeles; the J. Paul Getty
Museum, Los Angeles; the Los Angeles County Museum of Art (LACMA), Los
Angeles; the Norton Simon Museum, Pasadena; and the Timken Museum of
Art, San Diego.

The history of the acquisition of Rembrandt paintings in Southern
California was one of separate, intensive pursuits over a period of just seventy
years. It is also the most recent chapter of Rembrandt in America, which
unfolded first in the major metropolitan centers of the East Coast. Guided by
the leading authorities on Rembrandt, wealthy magnates and entrepreneurs

———

of railroad and industry—H. O. Havemeyer, Joseph E. Widener, Henry C. Frick, Andrew W. Mellon, and others—acquired major holdings of Rembrandt paintings and bequeathed them to the Metropolitan Museum of Art and the National Gallery of Art, among several institutions. Included in this group were collectors with connections to the West Coast, such as Arabella Huntington, whose distinguished collection of French and English paintings and decorative arts would join the collections at The Huntington in San Marino, but whose three Rembrandts remained in New York after her death. None of the paintings acquired by Southern California collectors in the early twentieth century is today considered to be by Rembrandt's hand. When Valentiner's *Rembrandt Paintings in America* was published in 1931, only one of the 175 paintings he attributed to Rembrandt in North American collections was located in California: *Saint John the Baptist* in the William Randolf Hearst collection (now at LACMA, it is presently attributed to Govaert Flinck). It would be seven more years before J. Paul Getty acquired the *Portrait of Marten Looten* (no. 8), which he gave to LACMA in 1953.

The formation of Rembrandt holdings in the region continued slowly over the next few decades with the acquisition of *Saint Bartholomew* (no. 13) by Anne R. and Amy Putnam in 1952, taking its place among the small collection selectively assembled by the Putnam sisters and displayed in the Timken Museum of Art from 1965. Mr. Getty's purchase of the slightly later *Saint Bartholomew* (no. 6) at auction in London in 1962 went some way toward assuaging his wistful longing for the *Marten Looten*. It also heralded the beginning of a tide of acquisitions by Southern California collectors through the 1960s and 1970s amounting to nearly three-quarters of the paintings on view today: *Portrait of a Boy*, then believed to be the portrait of Rembrandt's son Titus (no. 12) in 1965 and *Self-Portrait* (no. 11) in 1969

by the industrialist Norton Simon; *Portrait of Dirck Jansz. Pesser* (no. 9) acquired for LACMA with the Hammer Purchase Fund in 1969; *The Raising of Lazarus* (no. 7), given to LACMA by H. F. Ahmanson and Co. in 1972; Hammer's 1976 acquisition of *Juno* (no. 2); and the purchase by Norton Simon in 1977 of *Portrait of a Bearded Man in a Wide-Brimmed Hat* (no. 10).

The activities of Mr. Getty, Dr. Armand Hammer, and particularly Norton Simon at that time stand in sharp contrast to their contemporaries elsewhere. Prices in the art market continued to escalate, and competition for outstanding works by Rembrandt was fierce in light of limited quantities of available pictures and evolving opinions about attributions to the master. Following the purchase of *An Old Man in Military Costume* (no. 3) by the Getty Museum in 1978 and Hammer's 1979 acquisition of the *Portrait of a Man Holding a Black Hat* (no. 1), no works were acquired in Southern California for another fifteen years, until the unusual early history subjects *The Abduction of Europa* (no. 4) and *Daniel and Cyrus before the Idol Bel* (no. 5) were secured by the Getty in 1995 through private sales. After two decades away from public view, the new private owner of *Portrait of a Girl Wearing a Gold-Trimmed Cloak* (no. 14) placed the painting on temporary loan to the Getty Museum in 2007.

Significantly, collectors and later institutions acquired Rembrandt paintings as part of broader collecting strategies defined by the quest for works of art of outstanding quality and rarity and as integral additions to the development of broad collections. None of the owners specialized in Dutch painting in particular, and most enjoyed expansive interests. Within a collection that ranged widely in medium and date, Norton Simon alone fashioned a remarkably selective and coherent group of Dutch pictures, which included three paintings by Rembrandt. Getty, Simon, and

Hammer spoke with unusual candor about their tastes and motivations and the significance of their Rembrandt paintings. In 1976, Getty described his consciousness of the great collectors of the 1920s and his own sense of inferiority, but also his sharp awareness of the new possibilities that opened up in the wake of the stock market crash. Armand Hammer, a physician, noted that he took particular delight in rare works and in discovering the tales behind them. Norton Simon began to collect in the mid-1950s to decorate his home, but he admitted in a 1965 interview to finding it difficult to identify which activity—art connoisseur and collector or businessman—was his primary pursuit.

The decisions of all three men were dictated by quality and by personal rapport with their pictures. However, they publicly emphasized other, more dramatic, aspects of their quests for exceptional works of art. Getty secured the *Portrait of Marten Looten* at auction after first seeing it in a Rotterdam exhibition. He later justified its removal from the Netherlands by characterizing the painting as a cultural ambassador to the United States. Although the *Titus* was the most expensive Old Master painting sold in Great Britain at the time (1965), it became more famous for the high drama of the sale itself. Simon had arranged an elaborate system of communication with Christie's auctioneer. When confusion arose during the auction and the painting was knocked down to another bidder, Simon protested vehemently and bidding was re-opened, with Simon emerging as the victor.

The press was actively recruited by these shrewd businessmen, not simply to document their acquisitions of major masterpieces, but also to heighten the prestige of their collections and their own celebrity. The *Titus*, for example, was trailed by a film crew as it disembarked at the airport in Washington, D.C. It later traveled to Los Angeles in disguise, gift wrapped

with a bow and a card reading: "To Mother with Love, Your Son." News of Hammer's acquisition of *Juno*, which he called the "crown jewel of my collection," could be found in many regional papers across the United States.

The acquisition of every Rembrandt painting was accompanied by elements of drama and even intrigue, but the most noteworthy story lies in the dedication, resources, and determination of Southern California collectors and ultimately in their munificent awareness of the ability of great art to move the viewer toward a stronger connection with the past and a greater understanding of human achievement.

ACKNOWLEDGMENTS: Many colleagues contributed generously to the creation of *Rembrandt in Southern California*. I particularly thank Cynthia Burlingham, Kristina Rosenberg, Scott Schaefer, Carol Togneri, and Amy Walsh for their advice and support. At the Getty, Michael Brand, David Bomford, Gregory Britton, Molly Callender, Erin Coburn, Catherine Comeau, Susan Edwards, Maria Gilbert, Benedicte Gilman, John Giurini, Mark Greenberg, Catherine Lorenz, Stacy Miyagawa, Merritt Price, and Silvina Niepomniszcze were instrumental in realizing this project.

THE PAINTINGS |

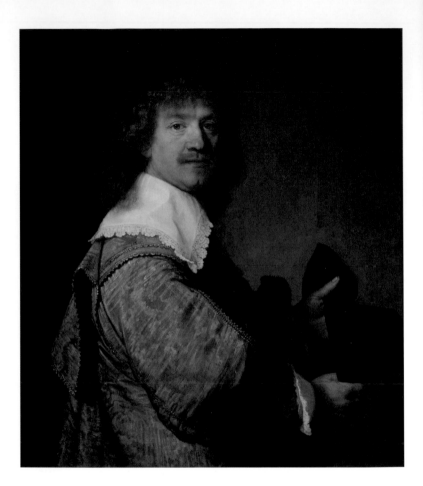

1. PORTRAIT OF A MAN HOLDING A BLACK HAT

THIS ELEGANT LIKENESS is in many ways unusual among the artist's portraits. Unlike his depictions of conservative Amsterdam merchants from the early 1630s such as *Portrait of Dirck Jansz. Pesser* (no. 9), Rembrandt here lavished attention on the rich taffeta costume, with its sharp brocade trim and complex sheen. The intricate texture of the sleeve contrasts with the thickly painted collar and its artfully curled lace edge.

Adopting a pose that shows the sitter's expensive accoutrements, Rembrandt revealed his familiarity with the innovations of his Italian Renaissance predecessor Titian while flattering his aristocratic or perhaps foreign sitter. The sense of movement recalls Rembrandt's *Portrait of Marten Looten* (no. 8). Typically for this period of the artist's career, strong light illuminates the man's right cheek, which is rendered with fine strokes in a yellowish tone, while different shades of pale gray are used for the whites of the eyes.

Portrait of a Man Holding a Black Hat, about 1639. Oil on panel, 31 $^5/_{16}$ × 27 $^5/_{16}$ in. (79.5 × 69.4 cm). Signed, lower right: *Rembrandt*. The Armand Hammer Collection, Gift of the Armand Hammer Foundation, Hammer Museum, Los Angeles, AH.90.59

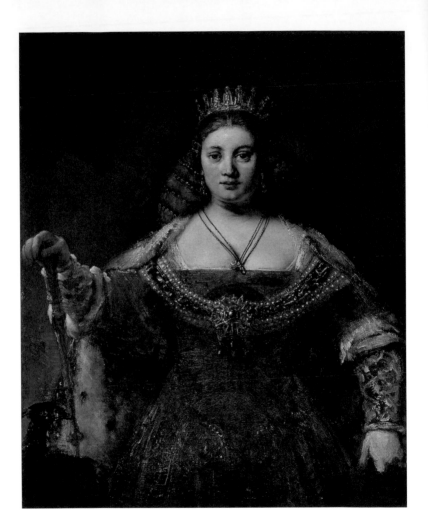

2. JUNO

JUNO IS THE MOST COMMANDING of a group of large-scale female subjects Rembrandt undertook in his last years. The wife of Jupiter, king of the gods, Juno was particularly associated with marriage and wealth. Here the artist employed an imposing frontal pose that creates an effect of calm majesty, which is reinforced by her widely spaced large eyes and the even illumination over her face and bodice. As he often did, Rembrandt allowed the dark underpaint to remain slightly visible around the eyes while adding strong white highlights to the center of the forehead and the end of the nose. Light marvelously illuminates Juno's right arm, scepter, and peacock from behind, and glitters off her gold crown, pearls, and jeweled brooch, much as in *Portrait of a Girl Wearing a Gold-Trimmed Cloak* (no. 14).

Juno, about 1662–65. Oil on canvas, 50 × 48 ¾ in. (127 × 123.8 cm). The Armand Hammer Collection, Gift of the Armand Hammer Foundation, Hammer Museum, Los Angeles, AH.90.58

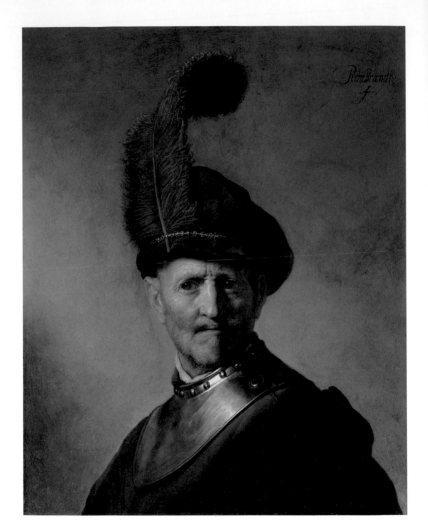

3. AN OLD MAN IN MILITARY COSTUME

REMBRANDT PAINTED MANY *tronies* (character studies from life) of aged men and women during his early career in Leiden, before 1631. The striking effect of this unknown subject derives from the intensity of his gaze and his fanciful costume, which includes a polished metal gorget (a piece of armor protecting the throat) and a tall ostrich plume. Positioned low in the pictorial field, the head is illuminated by cool light from the upper left, creating dramatic contrasts in the face and a sense of atmosphere in the neutral setting. Rembrandt sensitively accentuated the attributes of old age in the network of blurred wrinkles, sparse mustache and beard, and furrowed brow. The man's watery gray eyes, red in the corners, are rendered with great naturalness.

An Old Man in Military Costume, about 1630–31. Oil on panel, 26 × 20 in. (66 × 50.8 cm). Signed by another hand over original *RHL* monogram, upper right: *Rembrandt.f.* The J. Paul Getty Museum, Los Angeles, 78.PB.246

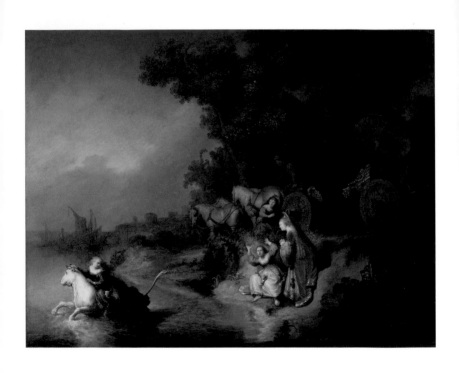

4. THE ABDUCTION OF EUROPA

WITH THIS DRAMATIC INTERPRETATION of Jupiter's seduction of Europa, princess of Tyre, Rembrandt confidently asserted his status as a worthy member of an elite circle of history painters. While closely following the ancient Roman poet Ovid's account, Rembrandt's own inclination to express profound human aspects of drama is clearly present: Europa's fingers dig deeply into the bull's neck, and her backward gaze links her directly to her attendants, who register a range of emotions, from horror to resignation. The youthful features and animated blonde locks of an unknown model (also depicted in *Portrait of a Girl Wearing a Gold-Trimmed Cloak*, no. 14) inspired the portrayal of both the princess and the standing woman in red. Rembrandt employed a range of brushwork and textures in this painting, from the thin reflections in the water to the heavy brocades and textured vegetation of the unusually prominent landscape.

The Abduction of Europa, 1632. Oil on panel, 24 ½ × 30 ⁵⁄₁₆ in. (62.2 × 77 cm). Signed, lower right: *RL.van Rijn. 1632*. The J. Paul Getty Museum, Los Angeles, 95.PB.7

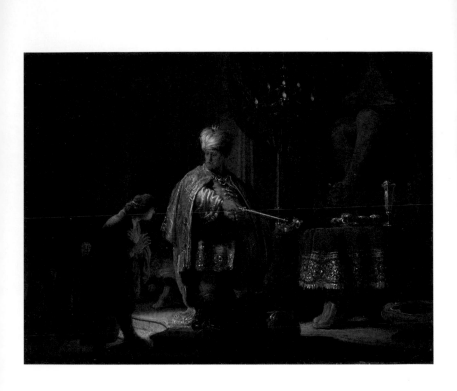

5. DANIEL AND CYRUS BEFORE THE IDOL BEL

DESPITE THE SMALL SIZE of this wood panel, Rembrandt captured the startling emotional climax of the key dramatic confrontation from the biblical Book of Daniel. As if on a stage, the oversized figure of the Persian king Cyrus stands at the center of an opulent temple. The humble yet resolute figure of Daniel, seen in profile, eloquently presses his accusation—that the king has been worshipping an idol—from the shadowy foreground.

The profound impact of their exchange registers clearly on Cyrus's face. Rendered with surprising breadth and fluidity for its scale, the work features dim areas that are thinly painted while Cyrus's dazzling cloak is more thickly executed. Along with *The Raising of Lazarus* (no. 7) and *The Abduction of Europa* (no. 4), this jewel-like work reveals Rembrandt's command of light effects and his vividly imagined biblical past, including fine details such as the tiny crown atop Cyrus's turban.

Daniel and Cyrus before the Idol Bel, 1633. Oil on panel, 9 ¼ × 11 ⅞ in. (23.4 × 30.1 cm). Signed, lower right: *Rembrandt f. 1633.* The J. Paul Getty Museum, Los Angeles, 95.PB.15

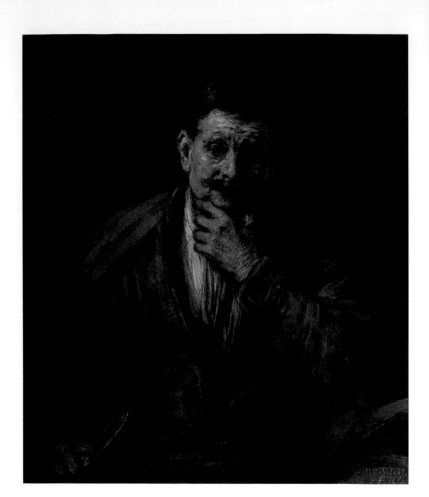

6. SAINT BARTHOLOMEW

REMBRANDT WAS A SENSITIVE INTERPRETER of the Bible, and he portrayed its larger-than-life figures as human beings with fears, passions, uncertainties, and fierce convictions. In his late religious portraits, he used friends and associates as models, uniting historical subjects with the immediacy of the portrait genre. The individualized features of Bartholomew suggest that a patron may have asked to be portrayed in the guise of the saint (an artistic convention known as a *portrait historié*). Bartholomew's pensive face is sculpted with thick, heavy strokes while the torso is thinly executed. His drab left hand hints at advanced age or even death, contrasting with the roughly indicated right hand, which holds a knife—the instrument of the saint's death by flaying.

Saint Bartholomew, 1661. Oil on canvas, 34 ⅛ × 29 ¾ in. (86.5 × 75.5 cm). Signed and dated, lower right: *Rembrandt.f. 1661*. Gift of J. Paul Getty, The J. Paul Getty Museum, Los Angeles, 71.PA.15

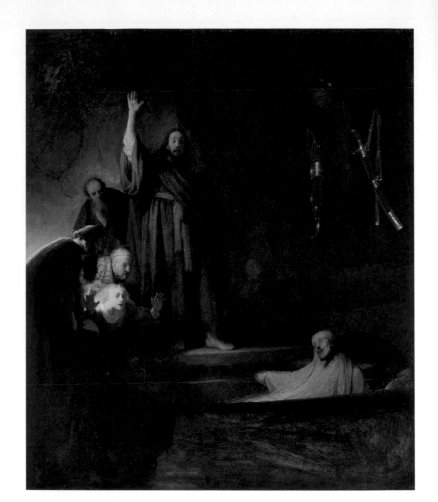

7. THE RAISING OF LAZARUS

REMBRANDT'S DRAMATIC PORTRAYAL of what is considered one of Christ's most extraordinary miracles—the raising of Lazarus from the dead— hinges on the connection across space between the commanding figure of Christ and the limp body of Lazarus. As he typically did in his early history paintings, Rembrandt used theatrical lighting and gestures to heighten the emotional impact of the scene. The beam of light penetrating the opening of the cave (at left) reveals both the miracle and the stunned reactions of the spectators. It highlights Christ's upraised arm and the white of his eye, spotlights the head and upraised hands of Mary Magdalene at his feet, and barely reveals the recoiling figure of a woman in the immediate foreground. The expressive faces of the old men are reminiscent of Rembrandt's character studies of the same period, such as *An Old Man in Military Costume* (no. 3). Scratch marks and raised golden highlights enliven the dark interior and draw attention to the glittering fittings of Lazarus's sword and other effects hanging on the wall above the tomb.

The Raising of Lazarus, about 1630. Oil on panel, 37 $^{15}/_{16}$ × 32 in. (96.4 × 81.3cm). The Los Angeles County Museum of Art, Gift of H. F. Ahmanson and Company, in memory of Howard F. Ahmanson, M.72.67.2. Photograph © 2009 Museum Associates/LACMA

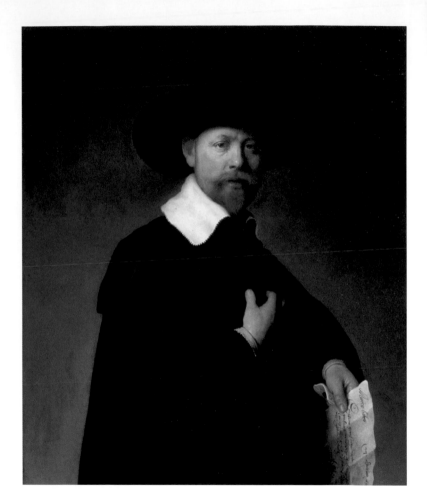

8. PORTRAIT OF MARTEN LOOTEN

REMBRANDT PROVED HIMSELF to be a master portraitist with this momentary likeness of Marten Looten, a prominent merchant, who appears to have been interrupted while reading a letter. The portrait was one of Rembrandt's first commissions after arriving in Amsterdam from Leiden. His skillful rendering of finely diffused light and delicate atmosphere creates a sculptural presence in a neutral space. Looten's Mennonite faith dictated his rich but sober attire, which Rembrandt captured with subtle distinctions of hue, using both the black beaver hat and cloaked torso as a foil for the sitter's inquiring expression. The application of paint is relatively thick and opaque throughout, notably in Looten's hands. Fine, textured brushstrokes describe the bright side of his face while thinner, more transparent application on his left cheek allows it to slip into shadow. The low, dark form of his hat across the forehead and subtle differences between the eyelids contribute to the intensity of his gaze.

Portrait of Marten Looten, 1632. Oil on panel, 36 ½ × 30 in. (92.7 × 76.2 cm). Signed in monogram on the letter: *RHL* and dated June 1632. The Los Angeles County Museum of Art, Gift of J. Paul Getty, 53.50.3. Photograph © 2009 Museum Associates/LACMA

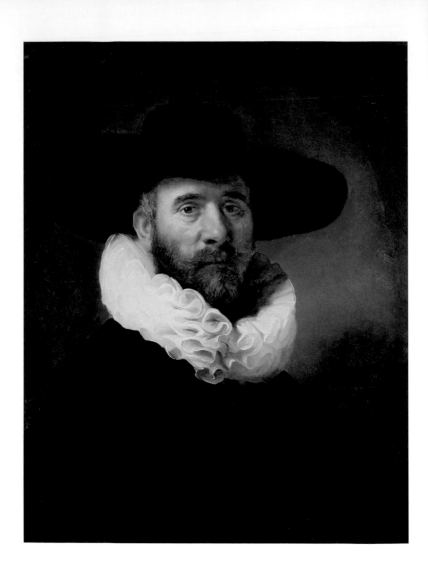

9. PORTRAIT OF DIRCK JANSZ. PESSER

REMBRANDT'S QUICK, DECISIVE APPROACH deftly captured the sitter's character in this early portrait of Dirck Jansz. Pesser, a prominent member of the conservative Remonstrant community in Rotterdam. Diffuse light falls gently and evenly across Pesser's face, where the combination of textures and warm tones lends a relaxed and accessible quality to the likeness. The strikingly free handling—visible in the thickly applied pigment around the eyes, the lively broken strokes of the mustache, and the sinuous edges of the ruff—reveals a more relaxed manner than that of *A Bearded Man in a Wide-Brimmed Hat, Possibly Peter Sijen* (no. 10), painted the previous year. Rembrandt executed this likeness in 1634, along with the portraits of Pesser's wife, *Haesje Jacobsdr. van Cleyburg* (now in the Rijksmuseum, Amsterdam), and Pesser's mother at the age of eighty-three, *Aechje Claesdr.* (now in the National Gallery, London).

Portrait of Dirck Jansz. Pesser, 1634. Oil on panel, 28 × 20 ¾ in. (71 × 53 cm). Signed: *Rembrandt. ft./ 1634*. The Los Angeles County Museum of Art, Frances and Armand Hammer Purchase Fund, M.69.16. Photograph © 2009 Museum Associates/LACMA

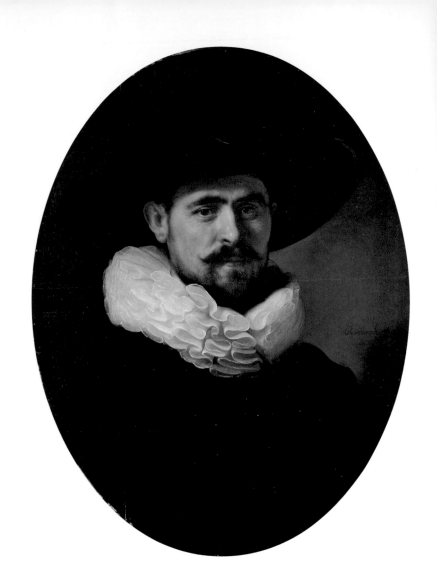

10. PORTRAIT OF A BEARDED MAN IN A WIDE-BRIMMED HAT, POSSIBLY PIETER SIJEN

THE STRONG SCULPTURAL EFFECT and tight brushwork evident in this likeness are characteristic of Rembrandt's early Amsterdam portraits, including *Dirk Jansz. Pesser* (no. 9). Intense light from the upper left creates a dramatic contrast between the two sides of his face and throws a shadow on the wall behind him. The light, which just catches the brim of his hat, brilliantly illuminates the folds of his white ruff, created with gray and taupe tones, but reveals little about his clothing. Certain key features—such as the subtle balance between the slightly turned position of the sitter and the volumes of hat and ruff—were important conventions Rembrandt used to create forceful likenesses in the 1630s. This portrait, possibly of the merchant and conservative Mennonite Pieter Sijen (about 1592–1652), was probably completed in late 1633 before the pendant of the sitter's wife, *Portrait of a Forty-Year-Old Woman, Possibly Marretje Cornelisdr. van Grotewal*, which is dated 1634 (now in the Speed Art Museum, Louisville).

> *Portrait of a Bearded Man in a Wide-Brimmed Hat, Possibly Pieter Sijen, 1633.* Oil on panel, 27 ½ × 21 ½ in. (69.9 × 54.6 cm). Signed and dated, center right: *Rembrandt f 1633*; inscribed, middle left: AET 41 [monogram]. Norton Simon Art Foundation, Pasadena, M.1977.31.P

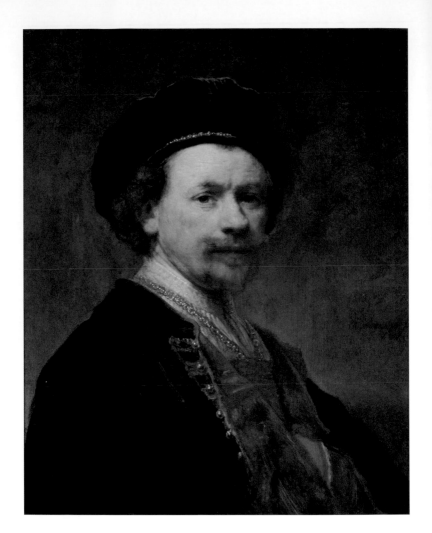

11. SELF-PORTRAIT

REMBRANDT DREW INSPIRATION from his own features and painted more than seventy self-portraits, many of which entered important contemporary collections. In this painting, Rembrandt tucks his left hand into the front of a garment that is an imaginative variation on a sixteenth-century tabard, or gown, lined in red. The highly convincing physical presence and the play of light over his features are characteristic of his approach in the late 1630s. The carefully worked face contrasts with the more broadly handled torso. Areas of looser gray brushwork around the torso are the artist's own corrections. The complex nature of this portrait, with its unusually vivid palette and disrupted brushwork in the face, suggests that it may have been left unfinished by Rembrandt and worked on by other artists in his studio and later. The effect may also be the result of cleaning and interventions, perhaps as early as the late seventeenth or early eighteenth century.

Self-Portrait, about 1638–39. Oil on panel, 24 ⅞ × 19 ¾ in. (63.2 × 50.2 cm). Inscribed and dated, center right: *Rembrandt f / 16_(.)*. The Norton Simon Foundation, Pasadena, F.1969.18.P

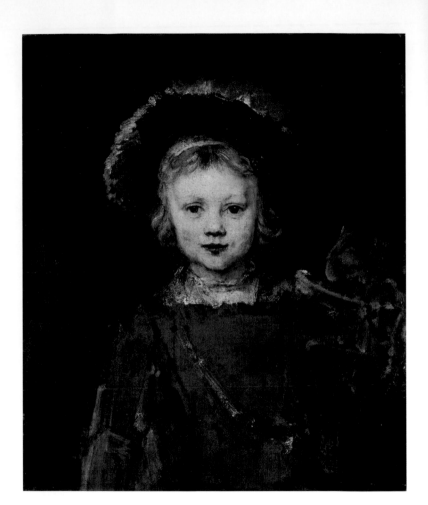

12. PORTRAIT OF A BOY

THE DIRECTNESS AND SENSITIVITY of Rembrandt's portrayal of this engaging young boy in semihistorical dress led to its previous identification as the artist's son Titus. Although that identification is now rejected, the identity of the sitter and the function of the painting, either as a fragment of a larger group portrait or as an independent likeness, remain undetermined. The unfinished state of the painting permits insight into Rembrandt's technique: worked over a mid-brown priming, individual broad strokes whose beginning and end are clearly visible suggest the general form of the boy's torso. Finely rendered strokes model the more fully described face, and red plumes on the soft black hat are quite freely handled. The loosely executed form on the boy's left arm may be an animal, possibly a monkey. Rembrandt adopted this frontal pose in later monumental figures such as *Saint Bartholomew* (no. 6) and *Juno* (no. 2).

Portrait of a Boy, about 1645–50. Oil on canvas, 25 ½ × 22 ½ in. (64.8 × 55.9 cm). The Norton Simon Foundation, Pasadena, F.1965.2.P

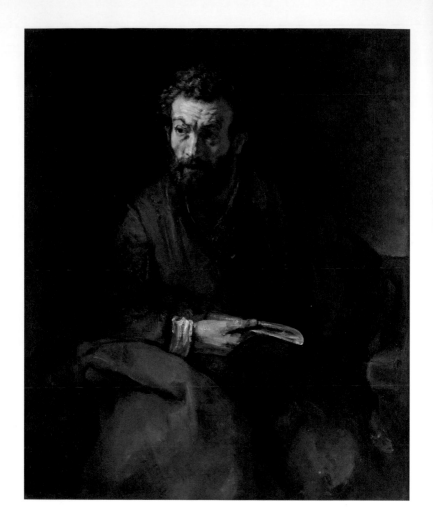

13. SAINT BARTHOLOMEW

IN THE LATTER PART of his career, Rembrandt undertook psychologi-
cally penetrating portraits of saints and apostles, perhaps as an artistic
investigation of spirituality. This animated portrayal is one of the largest
of a group that includes another introspective version of *Saint Bartholomew*
(no. 6). Here the dynamic pose of the apostle who preached the Gospel in
Asia attests to the physicality of his personality and the zeal of his mission.
In contrast to his assertive pose, he holds a knife, the instrument of his mar-
tyrdom, with relaxed ease. The broad, descriptive strokes of his hand and
cuff stand out against his roughly indicated cloak. Textured brushwork in
the face, in which the dark undertones play an important role in modeling,
contributes to the lively effect.

Saint Bartholomew, 1657. Oil on canvas, 48 ⅜ × 39 ¼ in. (122.7 × 99.7 cm).
Signed and dated, center left: *Rembrandt f. 1657*. The Putnam Foundation, Timken
Museum of Art, San Diego, 1952.001

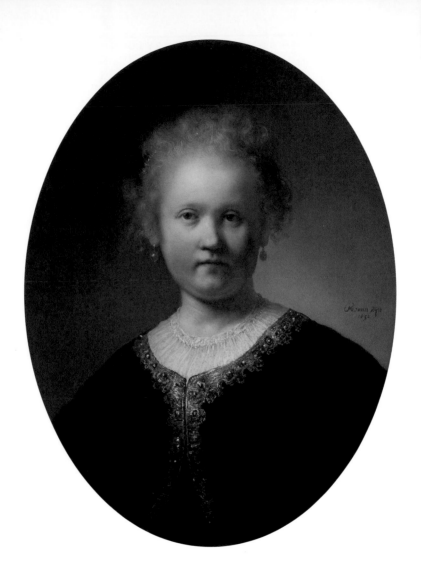

14. PORTRAIT OF A GIRL WEARING A GOLD-TRIMMED CLOAK

THIS WELL-PRESERVED *tronie* (character study from life) of a young woman who captured Rembrandt's attention in 1632 demonstrates his unrivaled command of light and the range of his descriptive brushwork. The subject was once thought to be the painter's younger sister, Liesbeth, but her fanciful costume identifies her as a type suited to historical or mythological subjects, such as *The Abduction of Europa* (no. 4). Adopting intense and direct illumination, Rembrandt masterfully achieved a soft, subtle atmosphere that creates a strong effect of physical presence and even allows tendrils of her hair and right earring to be lit from behind. Finely rendered strokes were used to build up the cheek and forehead and create strong highlights. Drier brushstrokes describe the folds of her blouse, while the sparkling, ornate gold decoration of her velvet cloak is handled quite freely and with robust texture, anticipating later works such as *Juno* (no. 2).

Portrait of a Girl Wearing a Gold-Trimmed Cloak, 1632. Oil on panel, 23 ¾ × 16 ⅞ in. (59 × 44 cm). Signed, right: *RHL* [in monogram] *van Rijn / 1632*. Private collection, temporary loan to the J. Paul Getty Museum, Los Angeles. Clayton Price Photography

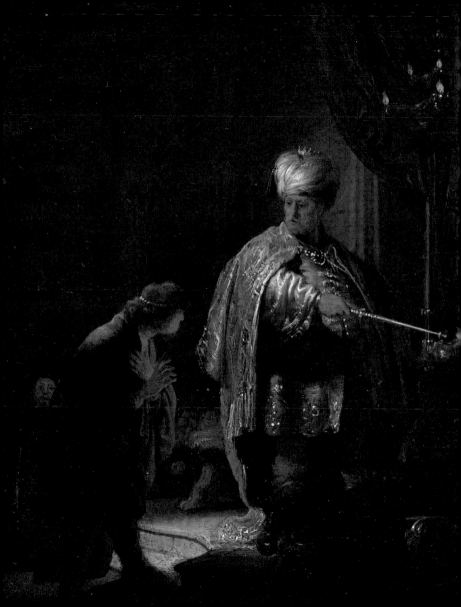

REMBRANDT AT WORK

———

THE RICH HOLDINGS of Rembrandt paintings in Southern California
museums represent nearly every phase of the artist's long and productive
career and offer an opportunity to consider some of the key facets of his in-
triguing working method.

TRONIES AND PORTRAITS

Rembrandt revitalized the traditional practice of portraiture by infusing
his likenesses with a greater plastic or sculptural quality, the suggestion of
animation, and far greater immediacy than his predecessors. His exploration
of physiognomy, often through self-portraits (no. 11) and *tronies* (character
studies from life; nos. 3 and 14) prepared the way for his future innovations
in portraiture and multifigure historical subjects. Portraiture was the most
lucrative aspect of his work—particularly at the outset of his career in Am-
sterdam—serving to attract not only new clients but also patrons for larger
civic projects, such as group portraits. His early patrons included associates of
the art dealer Hendrick Uylenburgh, with whom Rembrandt established his
Amsterdam studio. Marten Looten (no. 8) was a member of the conservative
Mennonite community, as was Uylenburgh, while Pieter Sijen (no. 10) lent
Uylenburgh money. Other patrons were the leading merchant and

———

explorer Jacques Specx, who likely owned *The Abduction of Europa* (no. 4). *Dirck Jansz. Pesser* (no. 9) and the richly attired, unknown *Man Holding a Black Hat* (no. 1) attest to Rembrandt's fame, which brought wealthy visitors to his studio and clients from other cities, including Rotterdam.

In portraits, important indicators of status, such as a sitter's costume, were carefully rendered. The play of light on fabric, even on a dark material such as the hat worn by Marten Looten (no. 8), was essential for suggesting volume. Projecting elements such as hats (whose contours almost always show slight corrections by the artist), along with the arcing curves of white ruffs created from grays and beiges and outlined with sinuous strokes, also contribute to the sense of volume and animation.

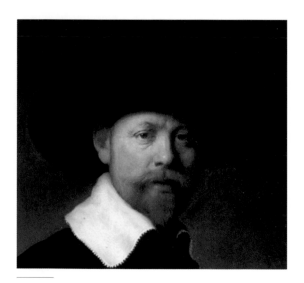

Portrait of Marten Looten (detail of no. 8).

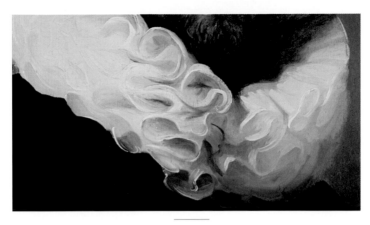

Portrait of Dirck Jansz. Pesser (detail of no. 9).

FACES AND FEATURES

Rembrandt placed the greatest emphasis on the faces of his subjects. In his early studies, such as *An Old Man in Military Costume* (no. 3), he strove to create dramatic areas of light and shade across the countenance of his sitter as well as a sense of atmosphere around the head. Rembrandt evidently relished the challenge of creating the transition to shadow on the far side of the face, and even the effect of backlighting (for example, the pearl in shadow in *Girl Wearing a Gold-Trimmed Cloak*, no. 14). Areas in strong light are generally more thickly painted, while those in shadow are more thinly executed. By employing the subtle technique of using radiating brushstrokes in the neutral background around the head and shoulders (clearly visible when viewed from a slight angle), Rembrandt effectively made the heads of his

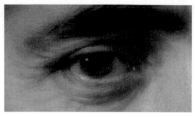

A small amount of white suggests moisture at the rim of the eye in *Portrait of a Bearded Man in a Wide-Brimmed Hat, Possibly Pieter Sijen* (detail of no. 10).

When viewed in raking light, radiating brushstrokes are visible in the upper left background of this detail from *Portrait of a Girl Wearing a Gold-Trimmed Cloak* (no. 14).

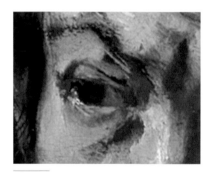

The dark underlayer helps define the eye socket in *Saint Bartholomew* (detail of no. 13).

subjects more prominent. This approach is most visible in *Portrait of Marten Looten* (no. 8) and *Portrait of a Girl Wearing a Gold-Trimmed Cloak* (no. 14).

A close look at the portraits reveals how subtly Rembrandt maneuvered individual features, creating a series of imbalances that resolve into a convincing likeness: often one eye is higher than the other and differs in size. Slight variations in the color of the pupil and the size of the iris allow the eye to recede slightly. A thin, pale beige stroke suggests moisture (see, for example, *Portrait of a Bearded Man in a Wide-Brimmed Hat, Possibly Pieter Sijen*, no. 10; *Portrait of Dirck Jansz. Pesser*, no. 9; and *Portrait of a Man Holding a Black Hat*, no. 1). Later portrayals of historical and religious figures, such as *Juno* (no. 2) and *Saint Bartholomew* (nos. 6 and 13), were probably inspired by contemporary men and women with whom Rembrandt was acquainted. In these late works, Rembrandt allowed the dark underlayer from the earliest stages of painting to remain visible, contributing to the appearance of the eye situated within the socket.

MATERIALS

Rembrandt used traditional materials, sometimes in surprising ways, to create striking visual effects. Innovative and spontaneous, the artist's brushwork reveals the speed with which he applied the paint as well as his changes and corrections during the execution of a work. Particularly in his early career, Rembrandt utilized oak panels, a traditional support for northern European artists that served to highlight his fine brushwork and jewel-like palette. He used a single, wide, radial-cut plank for *The Raising of Lazarus* (no. 7) and reused a panel upon which he had already started a male portrait by turning it 180 degrees before painting *An Old Man in Military Costume* (no. 3).

Rembrandt also purchased canvas in standard widths. While oval formats were popular for bust-length portraits in the 1630s—he used one for *Portrait of Dirck Jansz. Pesser* (no. 9)—they were also in style during the 1700s, when rectangular Dutch portraits of the previous century were cut into oval shapes. It is sometimes difficult to determine with certainty the original shape of a portrait (for example, *Portrait of a Girl Wearing a Gold-Trimmed Cloak*, no. 14, and *Portrait of a Bearded Man in a Wide-Brimmed Hat, Possibly Pieter Sijen*, no. 10).

Rembrandt occasionally allowed the preparatory, or ground, layer to show through in certain areas, making use of its color. The salmon-tinted layer is visible in the right ruff of *Portrait of a Bearded Man in a Wide-Brimmed Hat, Possibly Pieter Sijen* (no. 10). Somewhat unusually, the area left in reserve for the right edge of the hat brim was left uncorrected after the artist reduced the extent of the brim. Although secondary in importance to the face, the visual weight and distribution of the body were important aspects of the portrait.

CHANGES (PENTIMENTI)

Rembrandt frequently adjusted the contours of the shoulders of his sitters, as in *An Old Man in Military Costume* (no. 3) and his own self-portrait (no. 11). Sometimes he made dramatic changes to a composition, as in *The Raising of Lazarus* (no. 7), the extent of which is visible only through technical means, such as X-radiography. Other changes, or *pentimenti*, are more obvious: for example, he extended the tip of his sitter's right thumb in *Portrait of Martin Looten* (no. 8) and changed the contours of his cloak along the right side. The remainder of the red cloth on the table that originally extended across the front of *Juno* (no. 2) can also be seen.

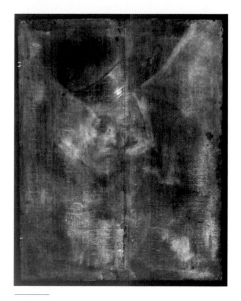

An X-radiograph of *An Old Man in Military Costume* (rotated 180 degrees) shows an earlier male head underneath the final painting (no. 3).

PAINT: GOUGING AND THE ROUGH MANNER

From the beginning of his career, Rembrandt paid particular attention to the texture and quality of paint. Among his works in Southern California are a number of good examples of the often-imitated practice of gouging in the wet paint with the wooden end of the brush. He used this technique sparingly, such as in the top of the feather of *An Old Man in Military Costume* (no. 3) and in the head and shoulder of

Portrait of a Man Holding a Black Hat (no. 1), or where he sought to create sophisticated light effects.

In *The Raising of Lazarus* (no. 7) gouging is evident in the face of one of the kneeling men, and it was used also to create the stringy foliage near Christ. It appears in the *Portrait of a Girl Wearing a Gold-Trimmed Cloak* (no. 14) in the edging of the white blouse where it is in shadow. This work reveals how Rembrandt freely daubed and dripped paint as well as created lumps of pigment to fashion the luxurious gold trim on her cloak. The artist often juxtaposed different types of brushwork in adjacent areas. This is clearest in late works such as the portrayals of Saint Bartholomew (nos. 6 and 13), where the thick and roughly painted faces contrast with the much more thinly or summarily painted torsos.

Rembrandt painted his apostles and evangelists in what his contemporaries called the *grof manier*, or rough manner. The expression was used by artists and critics alike to refer to the visible brushstroke, a dynamic and virtuoso technique, and a surface that was best seen from a distance. The broad and quite varied handling of his late style, however, was distinct from the elegant, polished style preferred by Amsterdam's elite around 1660. Committed to his singular artistic vision, Rembrandt continued to explore the scope of a rough and varied surface through the final years of his life, pushing the expressive possibilities of paint to its most evocative ends.

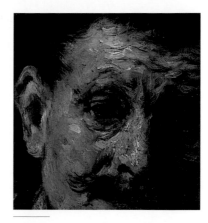

Unblended strokes make up the face in
Saint Bartholomew (detail of no. 6).

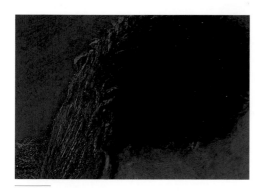

Probably using the wooden end of his brush,
Rembrandt gouged into the paint to create
texture in the feather in *An Old Man in Military Costume* (detail of no. 3).

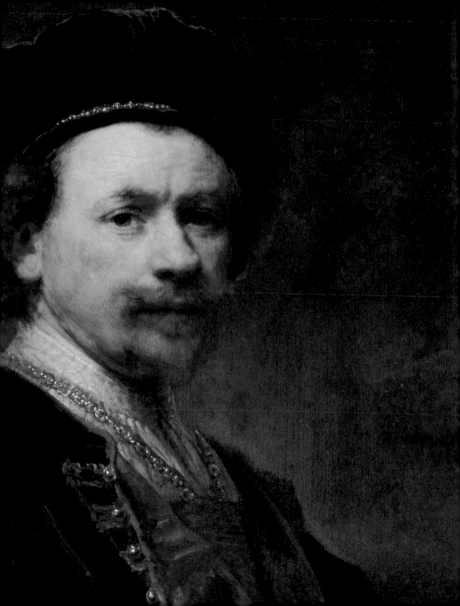

BIOGRAPHY OF REMBRANDT

REMBRANDT HARMENSZ. VAN RIJN

b. 1606 Leiden, The Netherlands, d. 1669 Amsterdam, The Netherlands;
Painter, Draftsman, Engraver; Dutch

BORN IN LEIDEN ON JULY 15, 1606, Rembrandt Harmensz. van Rijn
was the ninth child of well-to-do millers. The van Rijn family was Prot-
estant and sympathetic to the Remonstrant faith, which opposed Calvin's
teachings on predestination. In 1620, after two years at Leiden University,
Rembrandt became a pupil of Jacob van Swanenburgh (1571–1638). He
subsequently moved to Amsterdam to apprentice with the leading history
painter in the Netherlands, Pieter Lastman (1583–1633), absorbing his
colorful palette and eloquent narrative approach. After six months, Rem-
brandt returned to Leiden and established his own studio. During the late
1620s, Rembrandt enjoyed a friendly rivalry, and perhaps also a studio,
with the painter Jan Lievens (1607–1674), with whom he shared an ambi-
tion to become a leading painter of history subjects. Gerrit Dou (1613–
1675) was among Rembrandt's early students. In 1628, the connoisseur
Constantijn Huygens praised Rembrandt as a "celebrated" youth, whose
talents outshone both the place of his birth and his teachers.

Moving permanently to Amsterdam in late 1631, Rembrandt established his studio in the art dealer Hendrick van Uylenburgh's premises on Sint Antonisbreestraat. Their joint business venture capitalized on the growing market for portraits and history paintings by Dutch artists. Rembrandt quickly became the most prominent painter of portraits, introducing greater subtlety, presence, and animation to the genre, as well as innovative group portraits. The refined small-scale history pieces of the early 1630s gave way a few years later to forceful and vivid large-scale subjects that reflect the powerful influence of Rubens on the artist. Many students came to the van Uylenburgh "academy" to be trained in Rembrandt's manner of painting, including Jacob Backer (1608–1651), Govaert Flinck (1615–1660), and Ferdinand Bol (1616–1680). In 1634 Rembrandt married van Uylenburgh's niece, Saskia van Uylenburgh (1612–1642).

Rembrandt's success in the 1630s was reflected in his purchase in 1639 of a grand house on Sint Antonisbreestraat, which also served as his studio for work and the training of students. He avidly continued to acquire paintings, drawings, prints, and curiosities for his collection. Rembrandt successfully controlled the availability of his own etched and engraved works, actively working to create market demand for them. In ill health following the birth and death of three children, Saskia died in 1642, leaving Rembrandt with their sole surviving offspring, a son called Titus. In the same year, Rembrandt completed the enormous group portrait of the Kloveniers militia guild, known as the *Nightwatch* (Amsterdam, Rijksmuseum). By the late 1640s, declining portrait commissions and disastrous speculative investments created financial strain on the artist. Following the bitter end of his relationship with Titus's nurse, Geertje Dircx (1600/10–1656?), Hendrickje Stoffels (1626–1663) entered Rembrandt's household in 1647 and

became his companion for the rest of her life. Their only child, a daughter called Cornelia, was born in 1654.

In his later years Rembrandt returned to powerful religious subjects, creating works of great psychological complexity and monumentality. It was also a period fraught with personal difficulties, including insolvency and the sale of his house and collections in a series of auctions in 1657 and 1658. Rembrandt moved to a far smaller house on Rozengracht in Amsterdam, an area that was home to many artists. In order to protect his earnings, Rembrandt became the employee of a company, run by Hendrickje and Titus, set up to sell his drawings, prints, and paintings.

Rembrandt remained famous, although his vigorous, broad brushwork and glowing palette were at variance with the prevailing taste in the Netherlands for a smooth, elegant, courtly manner of painting. He continued to receive commissions for history subjects, private portraits, and important public works from local patrons and art dealers, as well as from collectors abroad. Rembrandt undertook a substantial group of large-scale religious figures in the late 1650s and early 1660s, revealing his profound interest in evoking complex psychological states. Due in part to the protection provided by Hendrickje and Titus's business, little is known about Rembrandt's studio in his late years. One student, Arendt de Gelder (1645–1727), is recorded working with him in 1661, and there may well have been others. Among Rembrandt's very last works were self-portraits, painted with vigor and expressiveness, in which the artist alertly fixes his gaze on the viewer. Rembrandt died on October 4, 1669, and was buried in Amsterdam's Westerkerk in an unmarked grave next to Titus and Hendrickje, who had both preceded him in death.

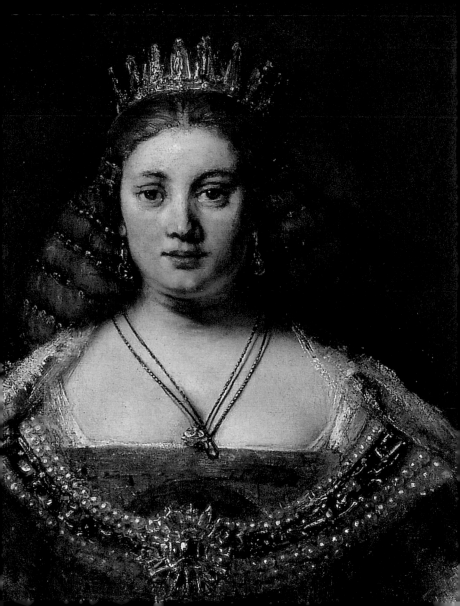

VIEWING THE PAINTINGS
IN SOUTHERN CALIFORNIA

WORKS OF ART are occasionally removed from the galleries for conservation or traveling exhibitions. Be sure to check with the owning institutions before your visit to confirm that a particular work of art is currently on view.

AUDIO TOUR

Take a roving audio tour of Southern California's Rembrandt paintings with curators from each museum. Featured are works from the Hammer Museum, the J. Paul Getty Museum, the Los Angeles County Museum of Art (LACMA), the Norton Simon Museum, and the Timken Museum of Art. Fourteen paintings are included, and the audio tracks are each about two minutes. Listen to the audio online or download it to your iPod or other MP3 player at www.rembrandtinsocal.org.

VIRTUAL EXHIBITION AND RELATED PROGRAMS

www.rembrandtinsocal.org

SOUTHERN CALIFORNIA ART MUSEUMS
WITH REMBRANDT PAINTINGS

1 HAMMER MUSEUM
10899 Wilshire Boulevard
Los Angeles, CA 90024
(310) 443-7000
www.hammer.ucla.edu

2 THE J. PAUL GETTY MUSEUM
at the Getty Center
1200 Getty Center Drive
Los Angeles, CA 90049
(310) 440-7300
www.getty.edu

3 LOS ANGELES COUNTY
MUSEUM OF ART (LACMA)
5905 Wilshire Boulevard
Los Angeles, CA 90036
(323) 857-6000
www.lacma.org

4 NORTON SIMON MUSEUM
OF ART
411 West Colorado Boulevard
Pasadena, CA 91105
(626) 449-6840
www.nortonsimon.org

5 TIMKEN MUSEUM OF ART
1500 El Prado, Balboa Park
San Diego, CA 92101
(619) 239-5548
www.timkenmuseum.org

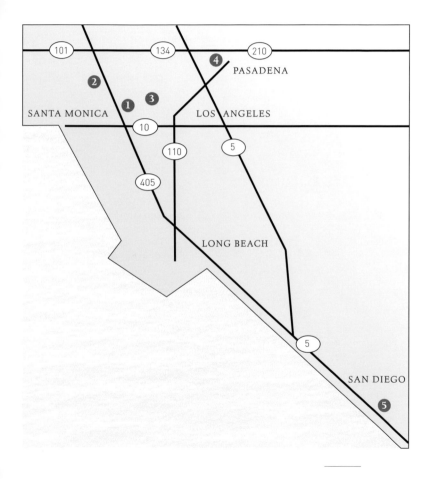

FURTHER READING

Alpers, Svetlana. *Rembrandt's Enterprise: The Studio and the Market*. Chicago: Univ. of Chicago Press, 1988.

Bomford, David, Jo Kirby, Ashok Roy, and Alex Ruger. *Art in the Making: Rembrandt*. London: National Gallery, 2006.

Brown, C., J. Kelch, and P. van Thiel. *The Master and His Workshop: Paintings*. Exh. cat. New Haven: Yale Univ. Press, 1991.

Bruyn, J., B. Haak, S. H. Levie, P. J. J. van Thiel, and E. van de Wetering: *A Corpus of Rembrandt Paintings*. 4 vols. The Hague and Boston: M. Nijhoff Publishers, 1982–2005.

Drawings by Rembrandt and His Pupils: Telling the Difference. Exh. cat. Los Angeles: Getty Publications, 2009.

Schwartz, Gary. *The Rembrandt Book*. New York: Abrams, 2006.

Slive, Seymour. *Rembrandt Drawings*. Los Angeles: Getty Publications, 2009.

Westermann, Mariët. *Rembrandt*. London: Phaidon, 2000.

Wetering, Ernst van de. *Rembrandt: The Painter at Work*. Amsterdam: Amsterdam Univ. Press, 1997.

Wetering, Ernst van de. *Rembrandt: Quest of a Genius*. Berkeley: Univ. of California Press, 2009.

Wheelock, Arthur K. *Rembrandt's Late Religious Portraits*. Exh. cat. Chicago: Univ. of Chicago Press, 2005.

White, Christopher. *Rembrandt*. New York: Thames & Hudson, 1984.

Williams, Hilary. *Rembrandt on Paper*. Los Angeles: Getty Publications, 2009.